D0894950

PREWAR SURFING PHOTOGRAPHS DON JAMES

INTRODUCTION BY MATT WARSHAW

T. ADLER BOOKS

SANTA BARBARA

ACKNOWLEDGMENTS

We would like to thank LeRoy Grannis and Jack Quigg (virtuoso board designer Joe Quigg's older brother) for taking the time to help us identify some of the surfers and locations featured in these photos, not an easy task considering the photos were taken 67 years ago (see page 45). LeRoy was part of the group of South Bay surfers appearing in many of the shots. Jack Quigg was with Don, and included in many of the shots, when these photos were taken. The surfers identified were: Gard Chapin, Gene Hornbeck, Barney Wilkes, E.J. Oshier, John Gates, Jim Reynolds, Tulie Clark, Kay Murray, Jim Bailey, Trux Oehrlin, Ed Fearon, Ralph Keiwit Jack Power, Bill Bowen, Bud Rice, Bob Side, Eddie Mc Bride, Ralph Saylin, Freddy Beckner, Roger Bohning, and Bud Morrisey. We apologize for overlooking anyone not mentioned. Graham and Laura Peake, John Bathurst and Barrett Tester. Randy Hild, Steve Pezman, Art Brewer, Jeff Hornbaker, Scott Hulet, Gary Lynch, Craig Stecyk, Steve Jones, Barbara Gonzales, Kari Simpson and Jody Beck. Gail Adler, Mike Murphy, Tom La Torre, Ken Herzog, Frank Boross, Peter Praed, Bob Guidry, Walter Gustafson, Kurt Blank, Trish Osborne, John Balkwill, Scott Gordon, Mark Burks, Rob Huggins, Richard Armstrong, Troy Hamilton, and Frank Schlegel who helped with the production. Ariel Meyerowitz, James Danziger, David Fahey and James Gilbert at Fahey/Klein and Atlas Gallery. Donna Wingate, Avery Lozada and Sharon Gallagher at DAP. Lee Kaplan and Babbette Hines at Arcana.

Edition prints and portfolios of selected images from the book are available.
Please contact archiv-e.com for information.

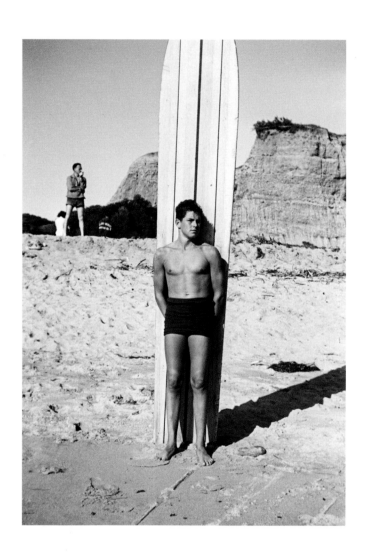

My entire seven-board quiver weighs less than Don James' balsa-redwood plank as seen on the opposite page. This is the kind of default monkey-mind impulse I have when glancing at old surfing photographs — to idly measure, by a variety of means and to no real purpose, the distance and differences between then and now. And with this collection of previously unpublished James photos, my first response pretty much boils down to a one shrill thought: *seventy years*! Or wait a second…*sixty-seven years*! Not to put too fine a point on it, but the majority of surfers in this book are dead. In a way, James' early work is also changing form. With each passing decade it becomes easier to view these kinds of primary surfing images not as a first step toward surf movies and magazines — or lifestyle ad fodder for Target, Ford and Kodak — but as part of history's half-inscrutable sepia-toned photographic record, folded in with shots of Civil War soldiers, Jazz Age romeos, and Dust Bowl refugees. There's something honorable in this transformation. But also something deadening.

Except the photos in this book aren't dead, they're just slowed way down, into kind of a visual tree-time. They require a calmer, mellower gaze, and the further you drop into the page-viewing Zen, the richer James' prewar surfing world becomes. Linger on these pages for more than a few minutes, in fact, and it's just about impossible not to drift off and wonder what it was like to live and surf in Southern California during the Roosevelt years; to hustle gas coupons and drive traffic-free down Highway One in a dingy Hudson roadster, stopping to poach avocados and oranges from roadside orchards; to casually pull lobsters and abalone from the rocky coves of Laguna Beach, and earn a few extra bucks by guiding Prohibition-busting rumrunners into the bay channels. I'm pretty well inoculated against surf nostalgia, and any Swing-era reverie eventually has to be checked against the hardships of the Depression. But I'm sent into a light trance at the notion of a Southern California beachfront without the shrieking levels of ambient information — billboards and signs, bass-thumping car stereos, ad-covered trashcans and lifeguard towers. Just 200 people, give or take, were surfing in California in 1937, when the photos in this book were taken. Did James and his high school friends know how good they had it? I wonder. Maybe not. Obviously they're having a great time; the best

time of their lives. But young Southern California surfers at this very moment are having the best time of their lives, on the very same beaches, while middle-aged grumps through the ages have complained about modern-day clang and clamber. Maybe surfing in the prewar years looks especially inviting for no other reason than the contrast between the beach and the unemployment line; between the lapping rhythm of waves on sand and the annihilating German blitz on Western Europe. Some of James' surfing friends were killed in action during the years between Pearl Harbor and VJ Day, which gives further poignancy, even romance, to these images, so here I am idly thinking of strumming ukuleles, and "Little Hula Heaven" summer weekend beach blasts at San Onofre, with rum drinks and coeds and sleeping bags, and Benny Goodman swinging from a hand-crank phonograph.

About 200 Don James images were discovererd in the back of a desk in his study, not long after James died, on Christmas Eve, 1996. Nearly all of the negatives were shot during a one-month period in late summer and early fall, 1937, when James was just 16. He wanted to explain to his parents and teachers what was happening in and around the surf, and photographs – especially those shot from the water – seemed like the best way. For water shots, James would place his father's fold-out Brownie camera in a homemade semi-waterproof pine box, rest the box atop his board, and paddle out to the calm water adjacent to the surf. At the opportune moment he'd pop open the spring-loaded box lid, raise the camera, aim and focus, hit the shutter, then quickly return the camera to the box. Focal range on the Brownie was limited, and James preferred to keep his frame uncluttered, so many of the images have a similar weight and balance. James' summer lifeguarding job paid for film, photo paper and chemicals. Two older surfer-photographers, Tom Blake and John "Doc" Ball, were the only other people who regularly shot surfing. None of the three were professional lensmen, but all were sharp-eyed, innovative and enthusiastic, and for the rest of the world the new sport came in view in large part through their images. James continued taking surf photographs into the 1990s. (For a more detailed look at James and his photography, see 1936-1942 *San Onofre to Point Dume*.)

Some photos in this book seem to end in a question mark. Like the Bluff Cove shot of page 26, where the first and third surfers are riding with their knees pressed together — to me this looks kind of stilted and beginner/intermediate, like a snow-plowing skier, but maybe this was in fact the advanced technique. The second surfer is meanwhile balanced on his front leg, and I'd guess he's about to dip his rear foot off the starboard rail to make a slight turn to the right. Or it could be the leg is just up there for show. This was years before the invention of cutbacks, noseriding, and climb-and-drop maneuvering. Performance options in 1937, in other words, were pretty limited, and maybe the best way to impress a photographer — not to mention the honeys on the beach and your pals riding on both flanks — was to glide shoreward in your best stork stance. And now all of a sudden I *really* want to know what the deal was with one-footed surfing. (A quick call to surf photographer and original Cove local Leroy Grannis, and I'm set straight. "No, it wasn't for show," he explained in his deep, slow, intelligent voice. "Sometimes you just had to stand there and balance for a second before you dipped your foot in. So maybe that's what's going in that shot." I got off the phone, looked again at this 67-year-old photograph, and marveled that I'd just spoken to somebody who was almost certainly out riding that very day.)

Other photos in this book, rather than opening a line of inquiry, instead seem to compress the surfing space-time continuum, or toss it out it altogether. Now I'm looking at the photo on page 9, of the three surfers just off the beach and starting to paddle out. The surf is medium-big and kind of junky; seven lines of whitewater are standing like hedgerows between the sand and the lineup, and who knows how many more waves these guys are going to have to punch through before landing in deeper water outside. And yet the surfer nearest the camera is *running*, too stoked to pace himself and conserve energy, and the whole thing looks like just about every paddle-out scene I've ever witnessed or been a part of up here in San Francisco's Ocean Beach. It's going to be a total chore, like 20 or 30 gasping minutes to make it out, but you run anyway because it feels so good, every time, then and now and for all surfing eternity, to make that ravishing transition from land to water.

Matt Warshaw is the author of the *Encyclopedia of Surfing*, and *Zero Break: an Illustrated Collection of Surfing Writing, 1778-2004*. He lives in San Francisco.

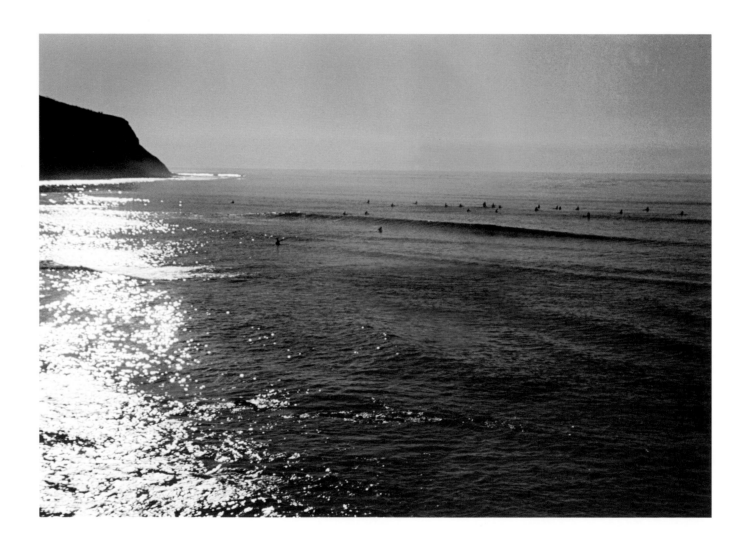

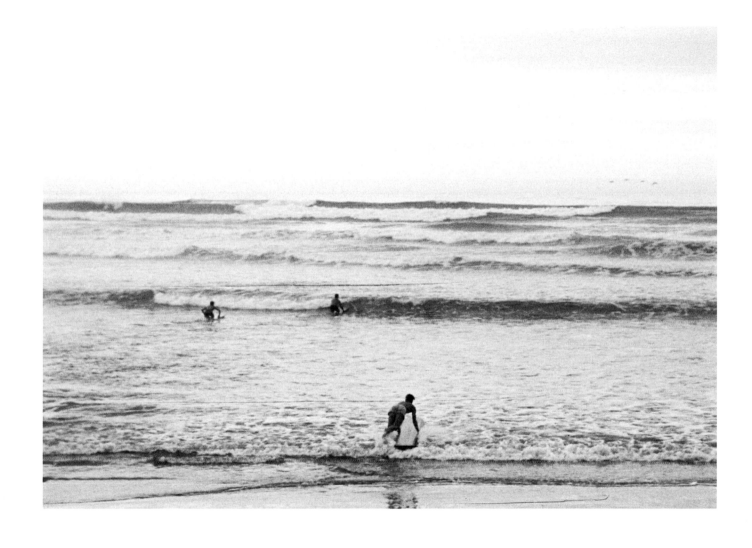

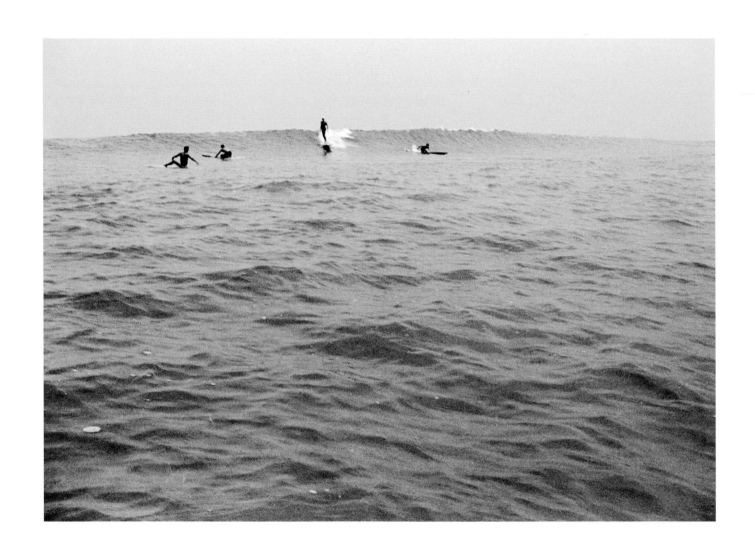

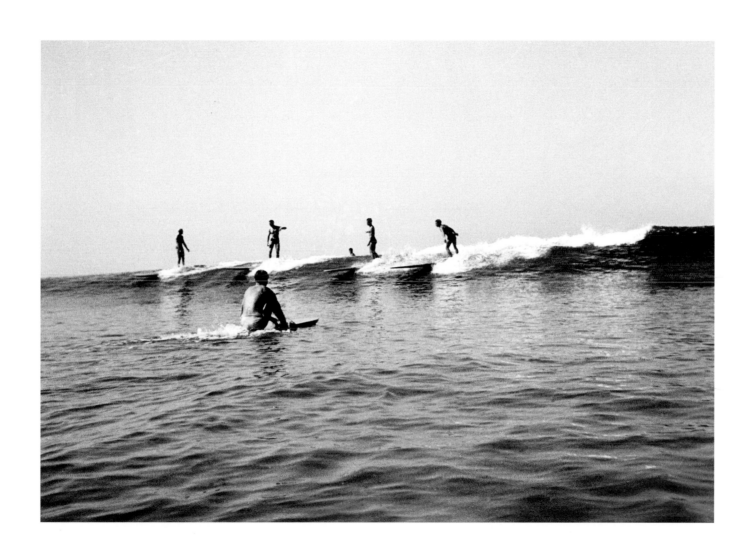

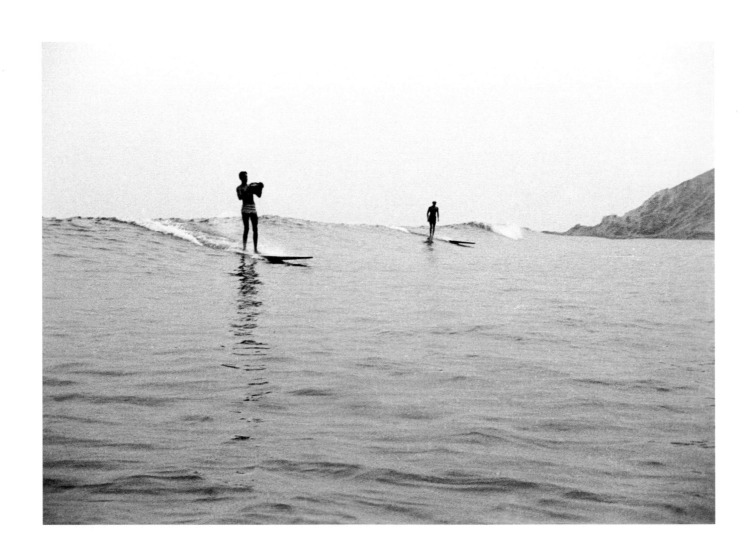

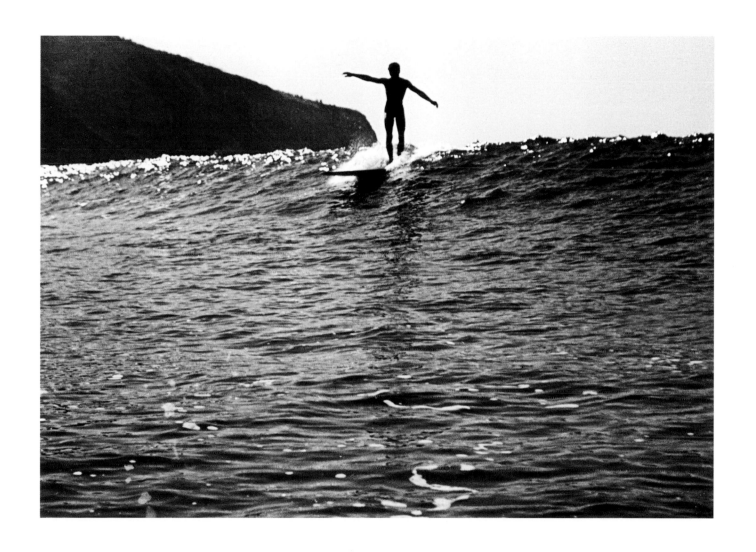

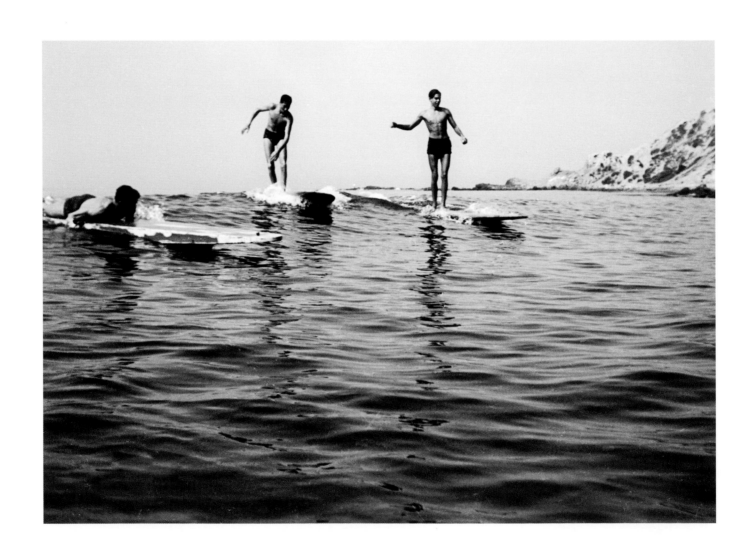

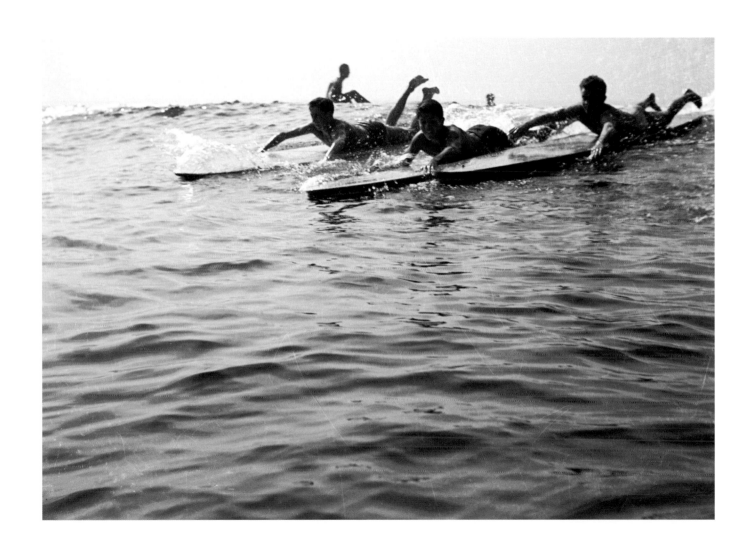

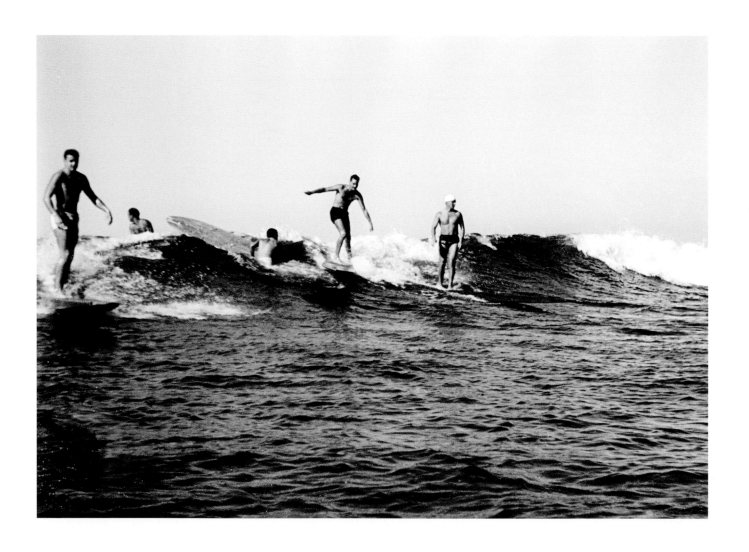

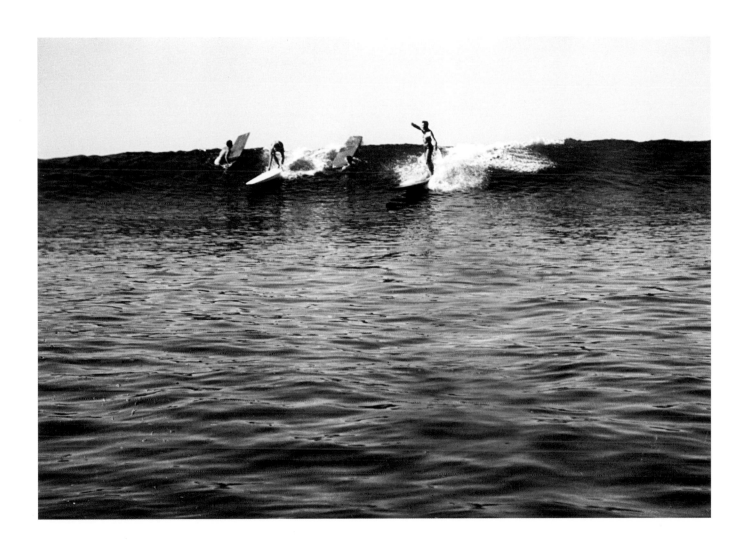

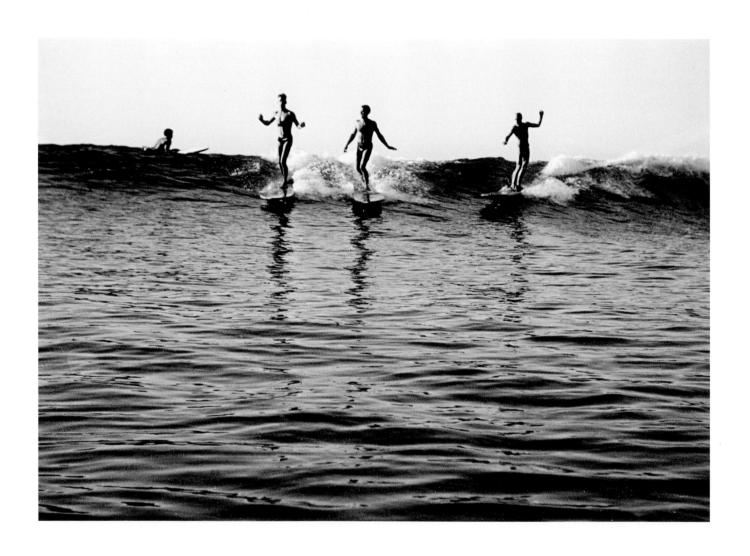

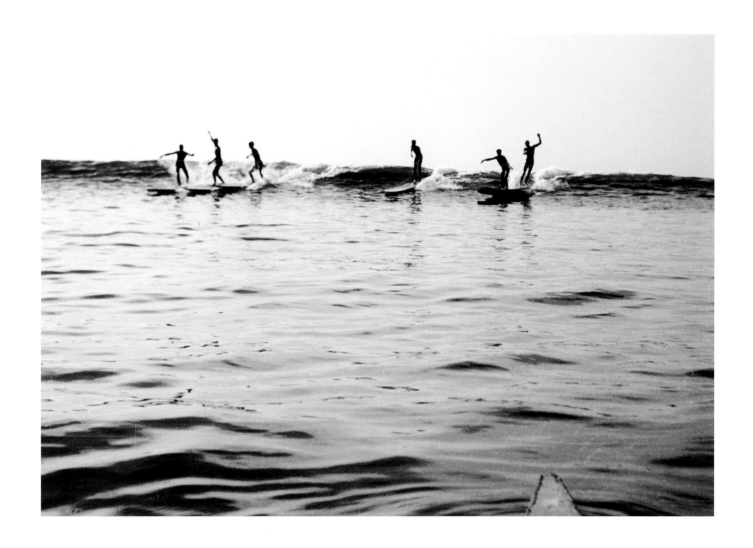

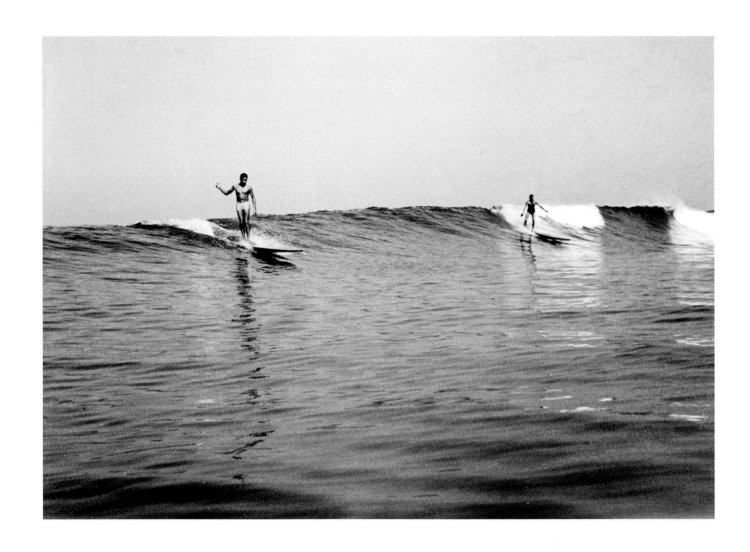

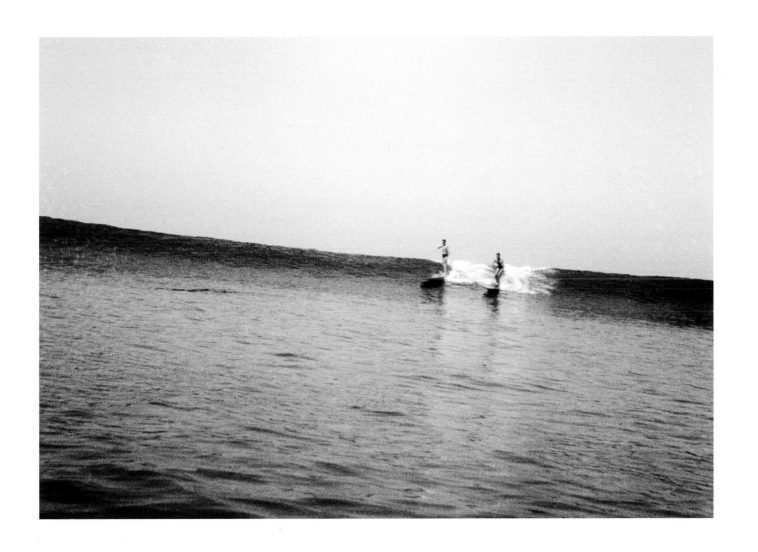

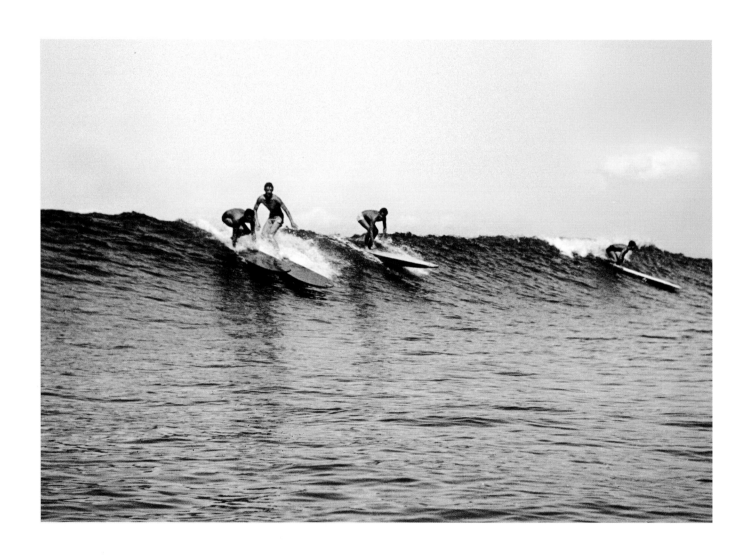

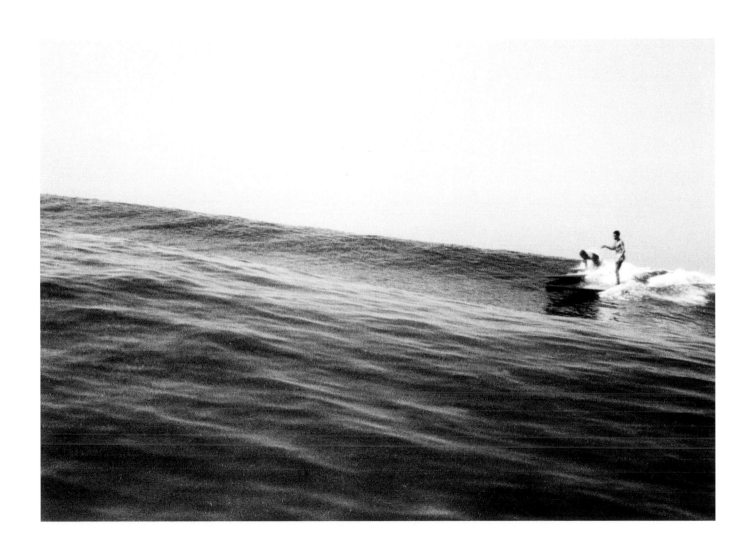

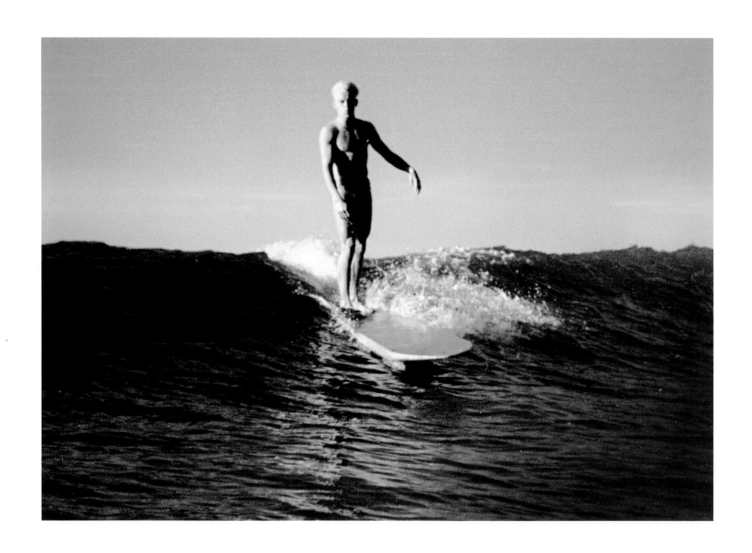

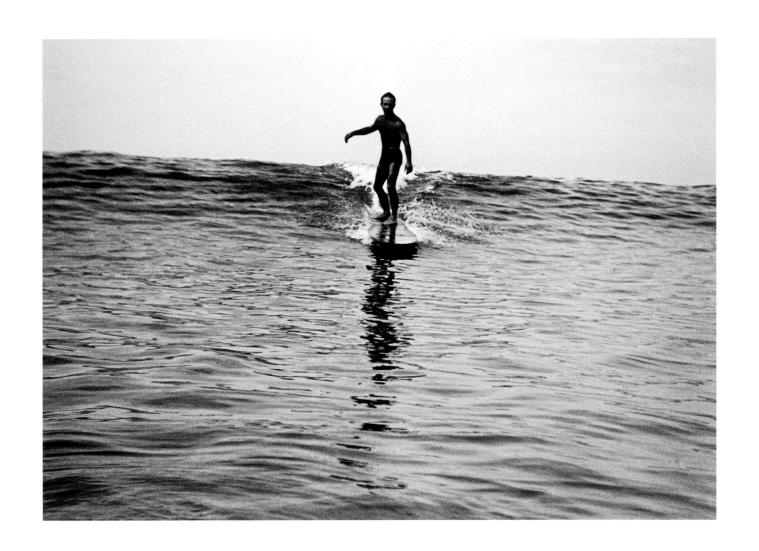

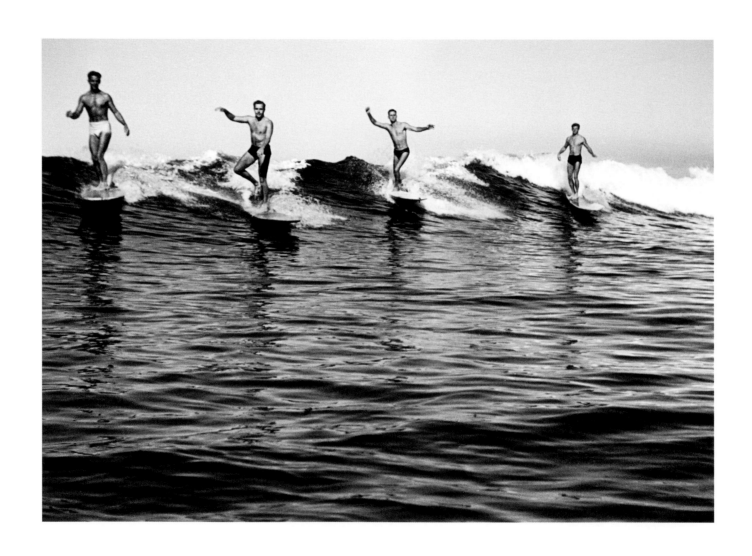

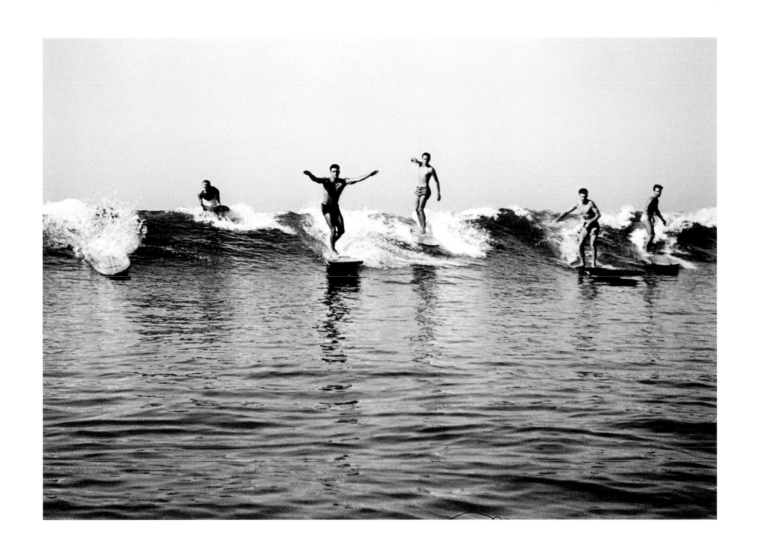

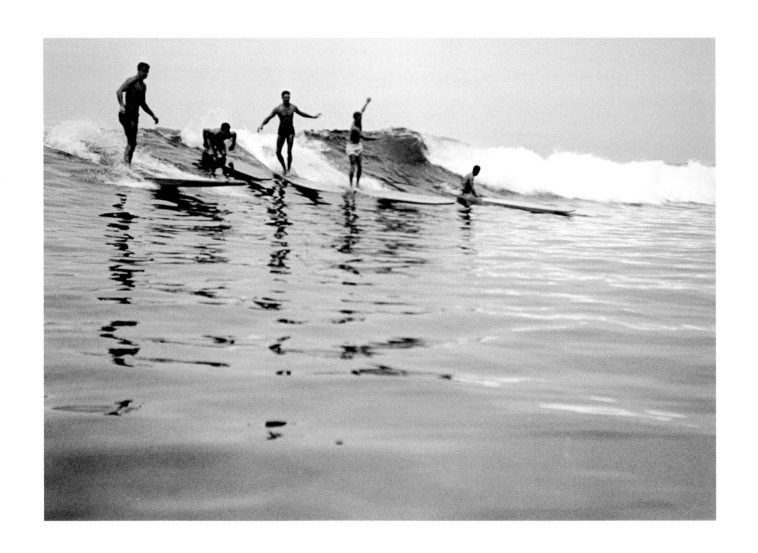

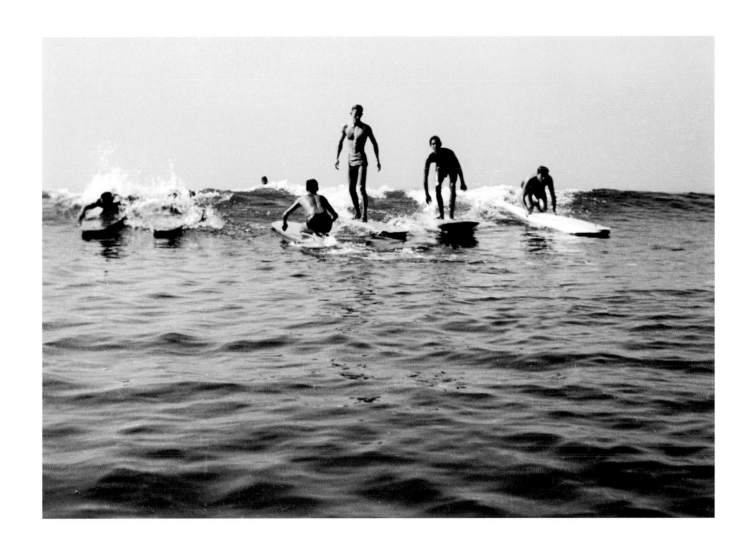

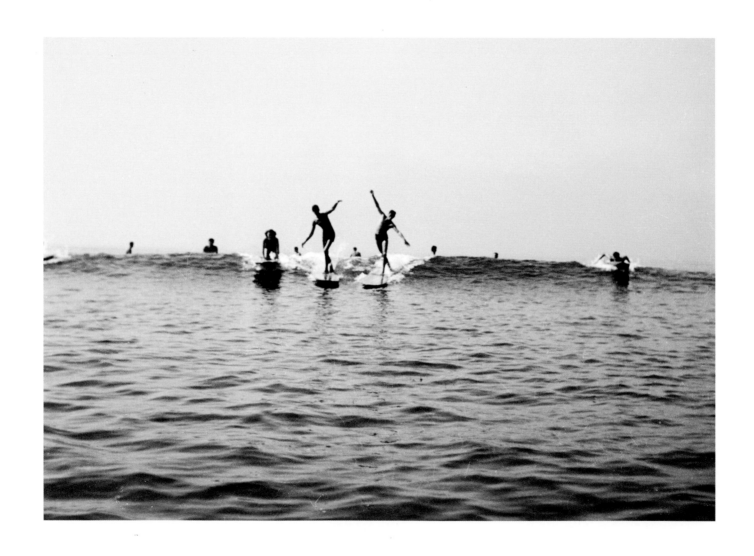

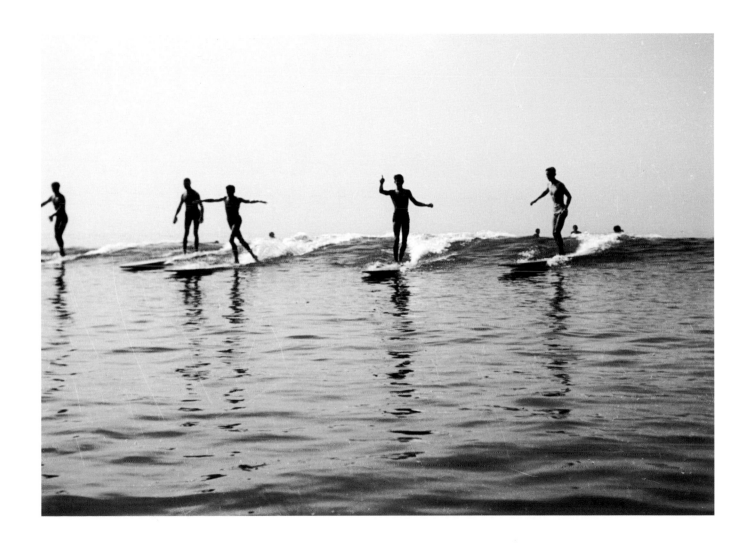

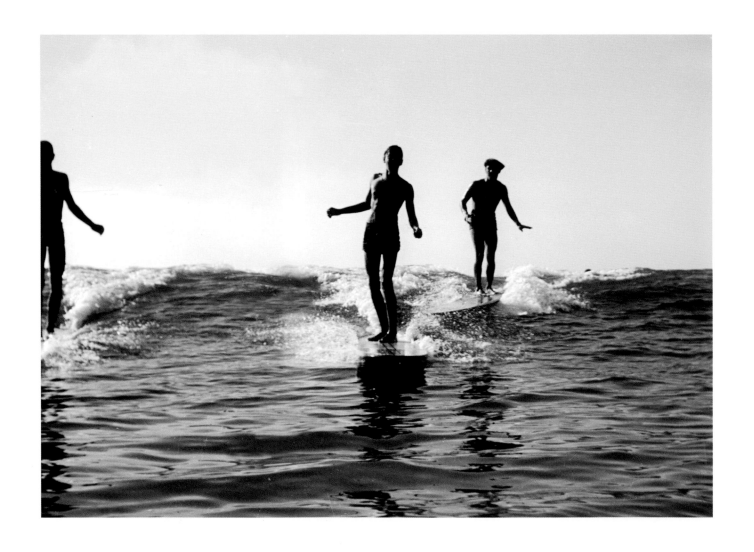

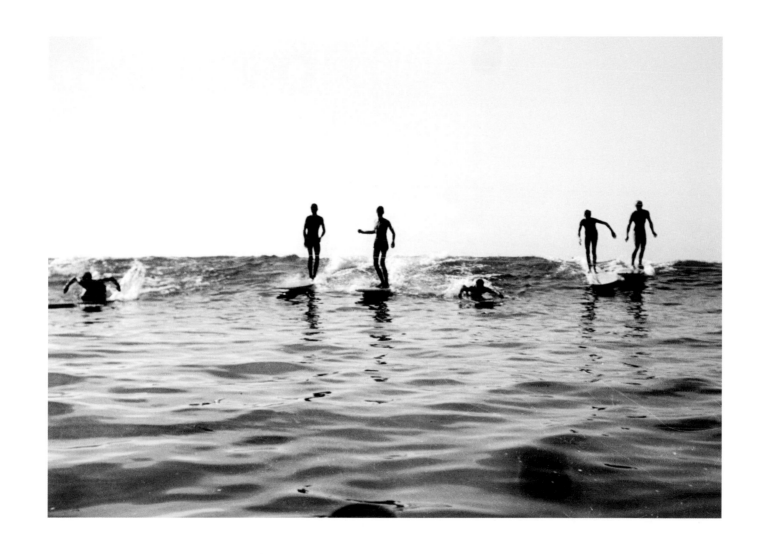

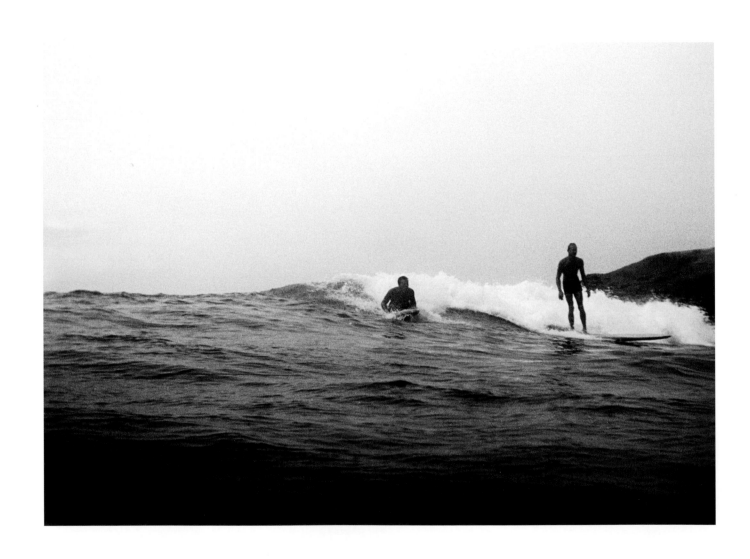

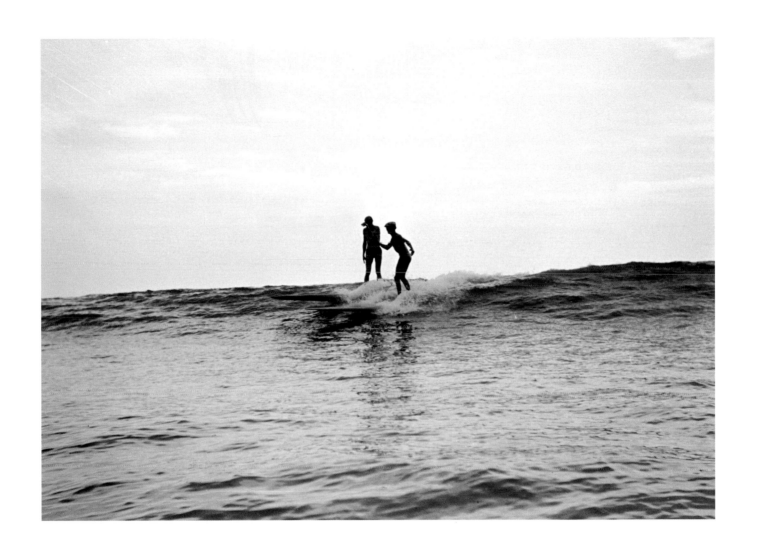

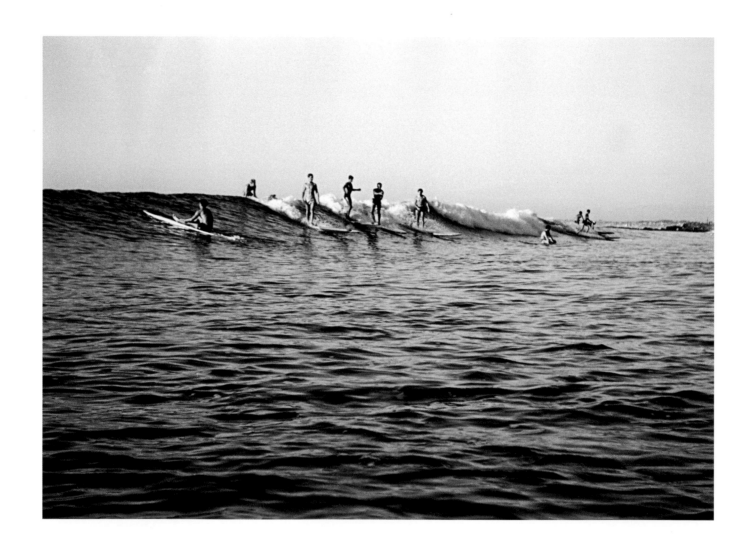

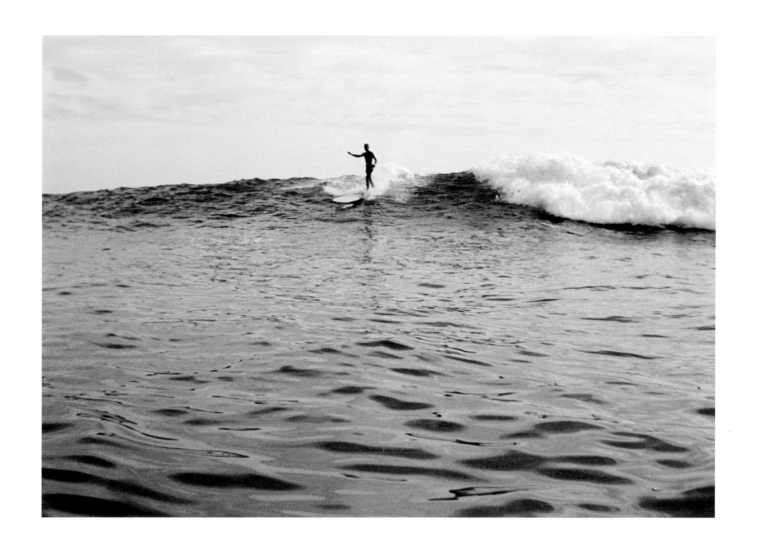

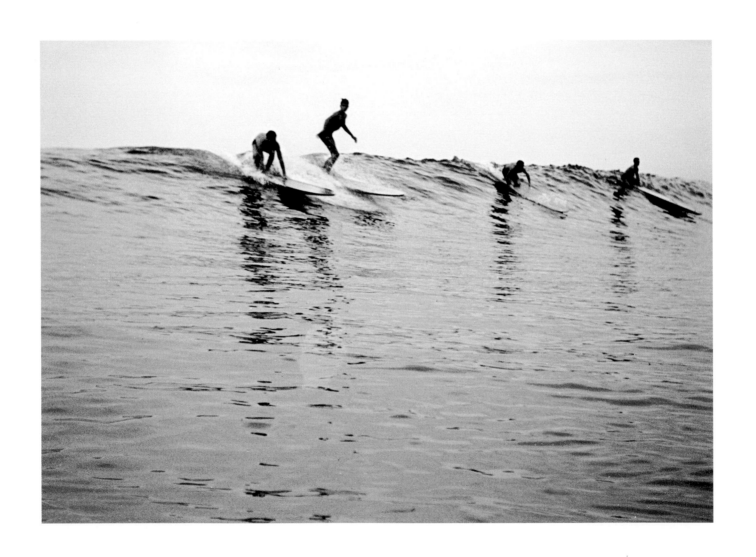

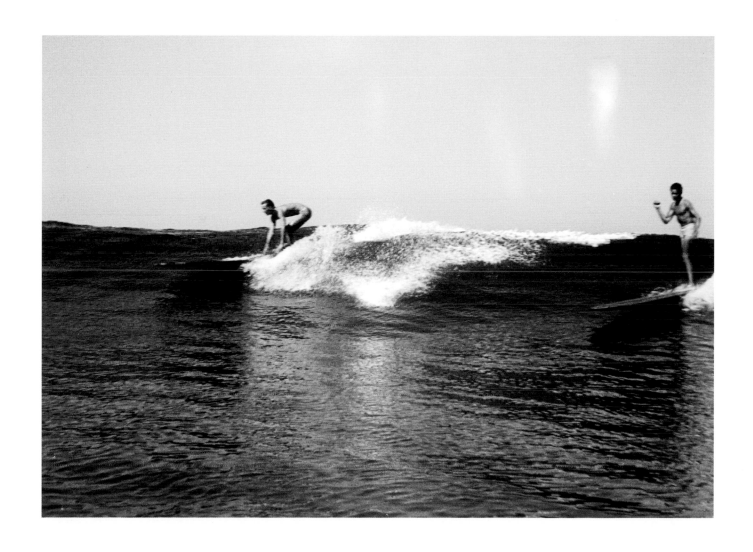

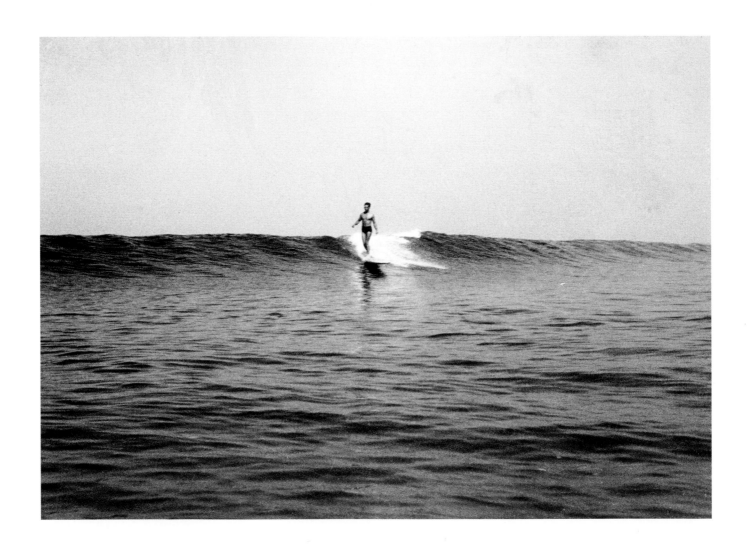

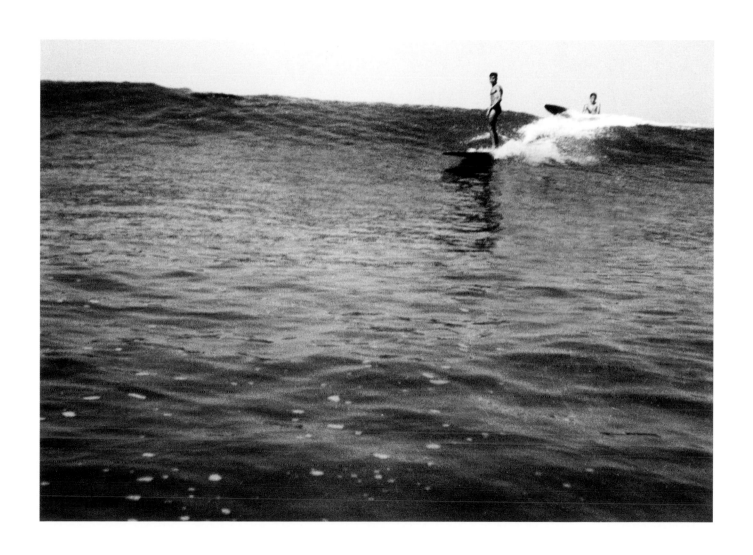

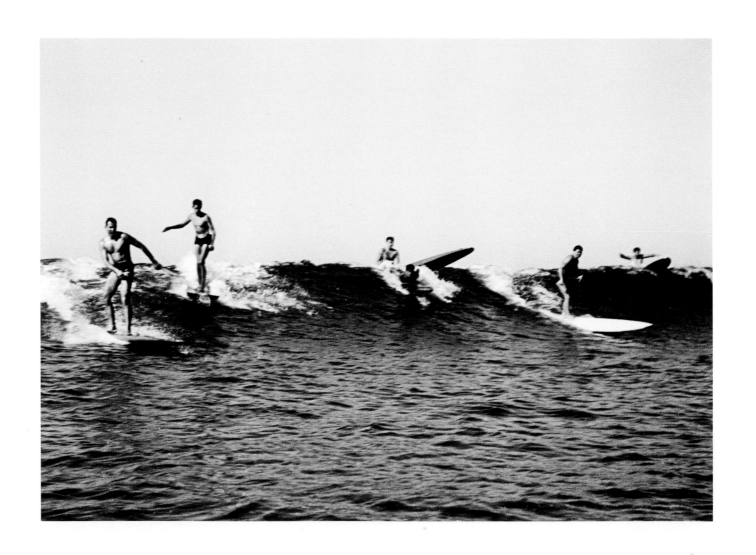

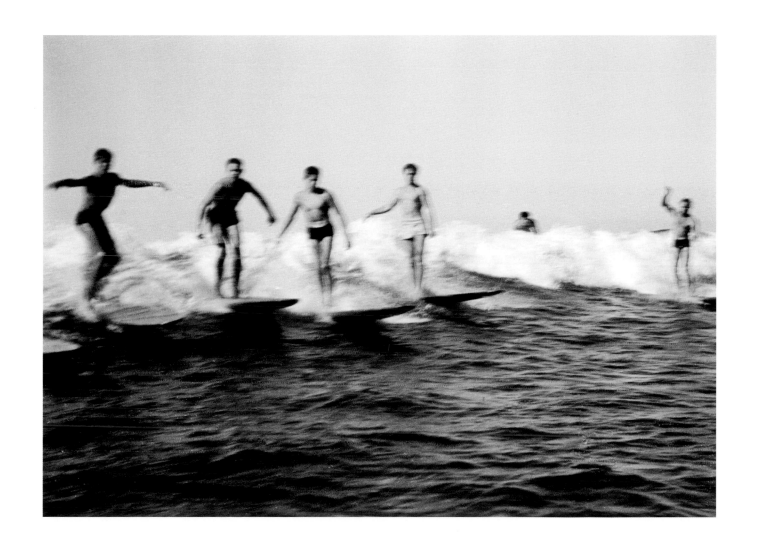

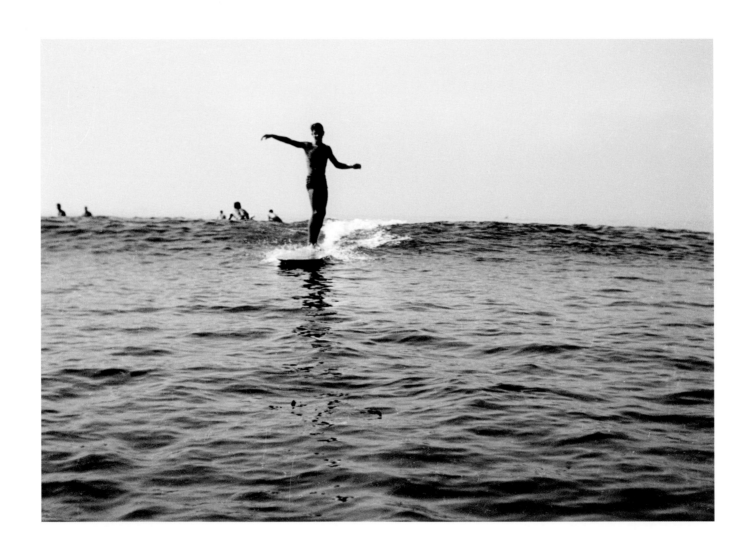

We asked Don's high school friend and surfing partner Jack Quigg to help us identify some of the people and places pictured in these photographs. We thought it would be nice, if he was so inclined, to write a few pleasant memories after reviewing the photos. Here is what came back. (Thanks Jack)

You asked for some memories. Here are a few:

Learning to ride on borrowed boards at State Beach at the mouth of Santa Monica Canyon, on a reef of rocks washed seaward over the eons. Well-shaped waves. Short trip. Bonus: a volleyball court on the sand.

Getting my first board, 11 feet, balsa and hardwood strips glued together, shaped and varnished. Feather light. Easy to maneuver. Floated high so you could keep your legs out of the cold water. Crafted in the garage of the Dana Point home of Loren Harrison, legendary surfer and waterman. Cost: $35.

Building a board locker: 11-1/2 feet high, 36" by 36", more or less. Made of 2x4's and 1x6's. Weighed a ton, or so it seemed. Being too young to drive, we persuaded a beach-area restaurant owner to let us put it in his back yard, half a block from the State Beach. We'd arrive by bike. Ye builders, alas, dwelt 25 blocks inland. To deliver locker to site we nailed skates to the four corners and hand-pushed it along San Vicente Boulevard to 7th street, then down the steep, curving hill into the canyon. Many stops for rest and repairs. Many a runaway checked just in time. (No brakes.)

State Beach footnote: in the late 1950s an errant Baja hurricane caused a massive canyon flood that wrecked some homes and businesses, cut a deep and wide gorge across Pacific Coast Highway, and ruined the surfing reef.

Living the sweet life in Malibu. The area now known as Surf Rider Beach was closed off back then by a high block wall that protected the mansion of a member of the family that once owned the entire coast from the film colony to the Ventura County line. We knew twas risky but we'd toss our boards over the wall, scale it and nestle out of sight in the small dunes. There we'd bask while playing Hawaiian songs on our windup portable record player. Warning: never leave a 78 rpm record on a blanket in the sun. It will shortly melt and assume the contours of the blanket. Out on the waves, we were visible. A couple of times the folks in the mansion, apparently called the sheriff as a deputy pulled up

and began hollering and waving us in. We pretended not to notice. But when we got back to our car the distributor cap was gone. Dead engine. To reclaim it we had to hoof it to the substation and listen to a lecture.

Camping at San Onofre required turning off the highway onto a dirt road that took you south. When you reached a bar with an attendant, you handed over a quarter and the bar went up. It was two bits every time you entered. At the surfing area—now a power plant—you'd pick a spot among camping riders from other areas and lay out your gear— sleeping bags and food for a week. From then on it was surf and sun and surf and sun. With a campfire at night.

Watching Don James—later to become a dentist and noted surf photographer—trying to invent a waterproof box for his camera. Trials and errors with assorted combos of wood and glass. Trials while he sat on his board shoreward of surfers, who tried to terrorize him by aiming right at him. Trials while treading water, snapping away at sea level as his pals skimmed within inches. He actually got some decent pictures.

Crossing pastures at Point Dume, watching alertly for fresh cow pies and aggressive bovines, scrambling down a cliff and swimming out to the rock reefs pushing an inner tube with burlap bag attached. Bagging bugs and abs sufficient for several dinners. And once, in knee-deep water, grabbing an 8-pound lobster that unwisely allowed his feelers to protrude from under a ledge.

Sideshow: Watching some lifeguards on a day off vying to bring up the most abs on one dive, sans SCUBA. They kept popping up from about 12 feet of water with large abs stuffed into their trunks, under their arms, between their legs, stacked against their chests. Loving it. Don't recall the winning number but it was in double digits.

Marveling at the hugest California waves we'd ever seen at Palos Verdes Bluff Cove one winter. The swells were big everywhere but when we arrived at the bluff the scene was awesome: endless lines of what we took to be 25 footers, with some larger. A sizable fishing boat off the point would be out of sight in wave troughs. The surfing area was a churning boil of white, no chance for a rider there, but had one been able to reach the point, he could have gotten a long, long ride of a lifetime into the bay.